T0043232

LUNA

COLORING BOOK

ILLUSTRATED BY MARIA TROLLE

GIBBS SMITH
TO ENRICH AND INSPIRE HUMANKIND

25 24 23 22 5

Luna
Illustrations © 2021 Maria Trolle.
www.mariatrolle.se
Instagram: @maria_trolle

Gibbs Smith
P.O. Box 667
Layton, Utah 84041

1.800.835.4993 orders
www.gibbs-smith.com

ISBN: 978-1-4236-5741-5

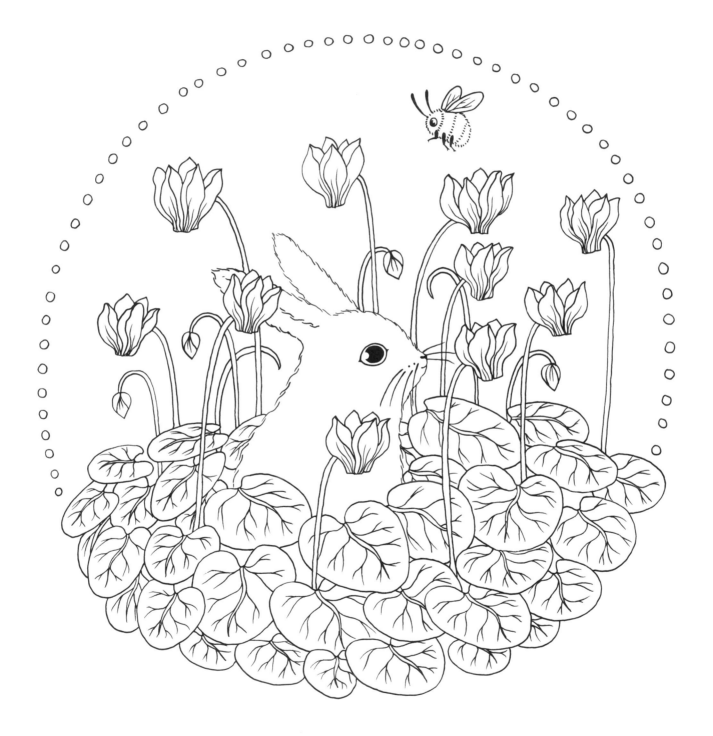

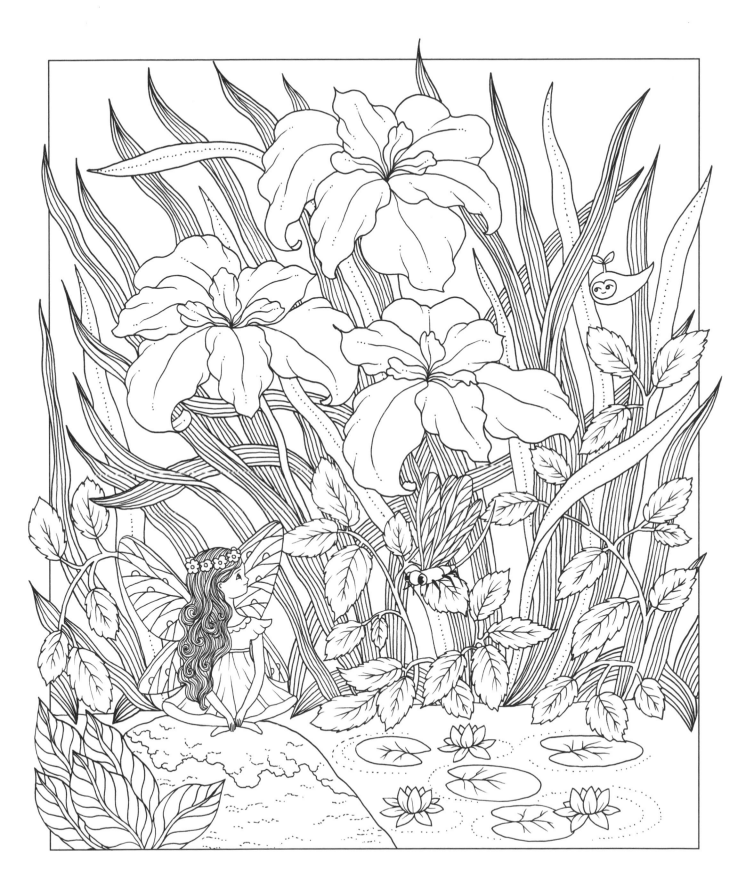

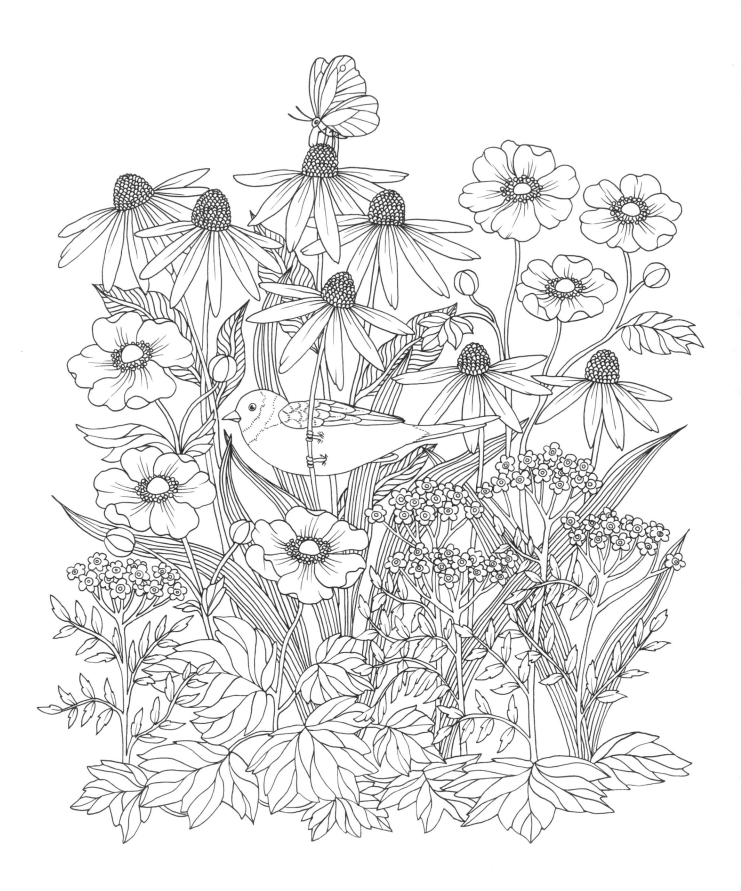

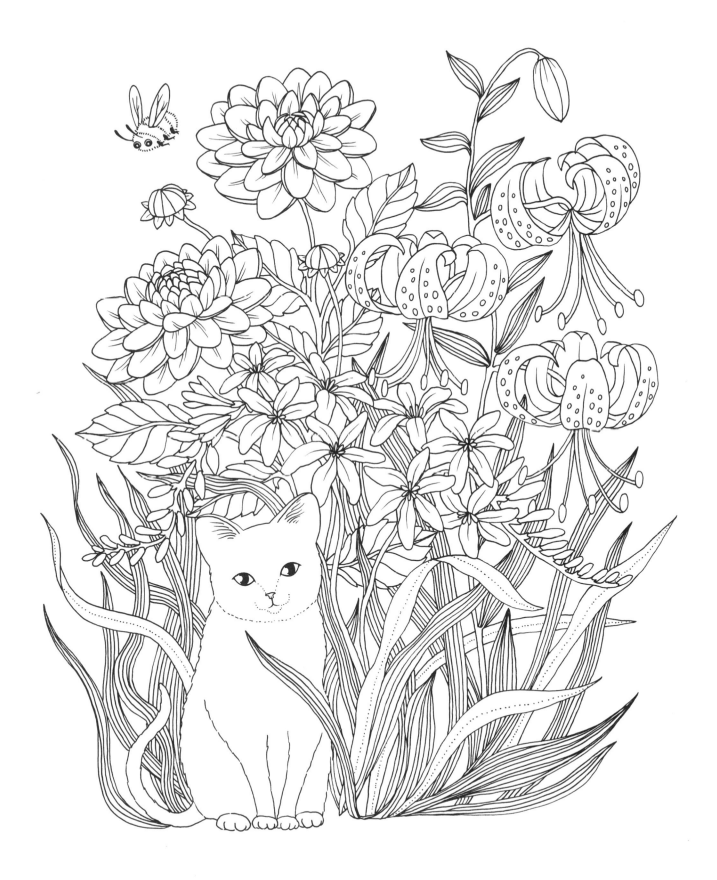

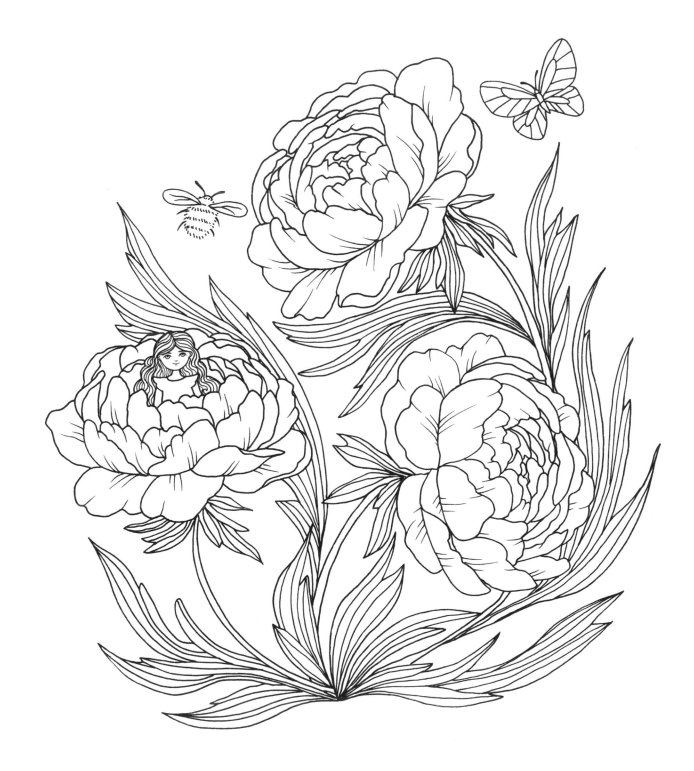

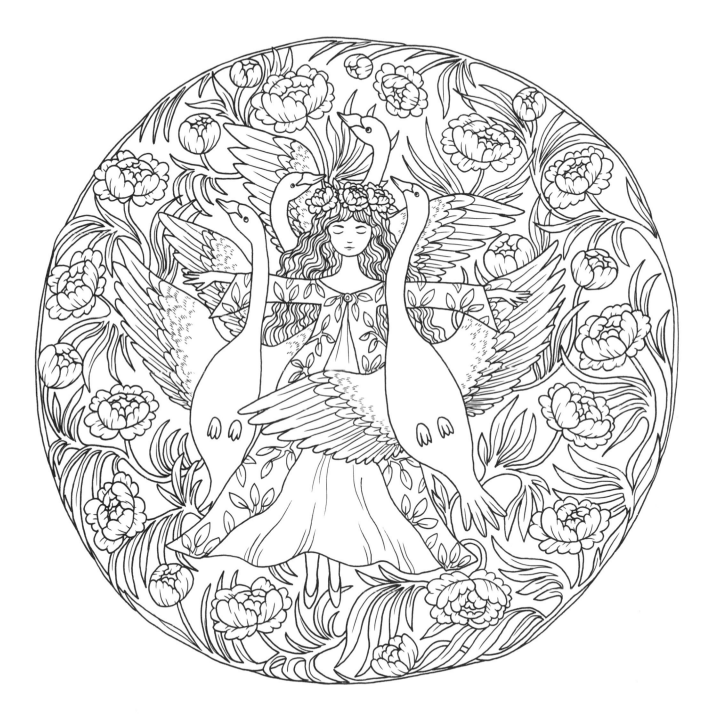

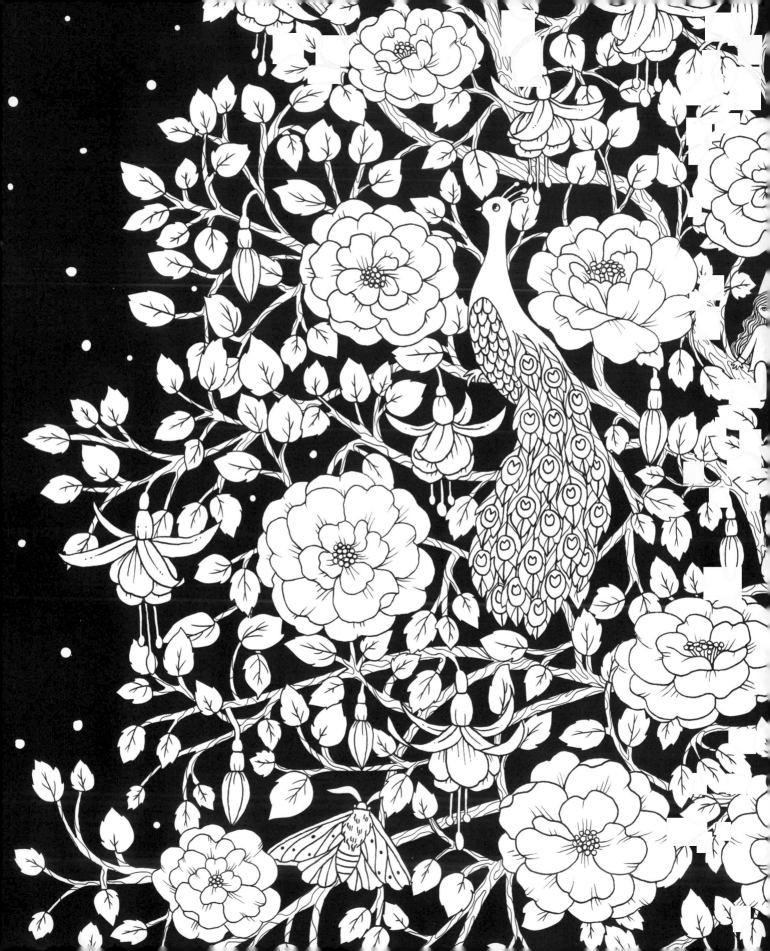

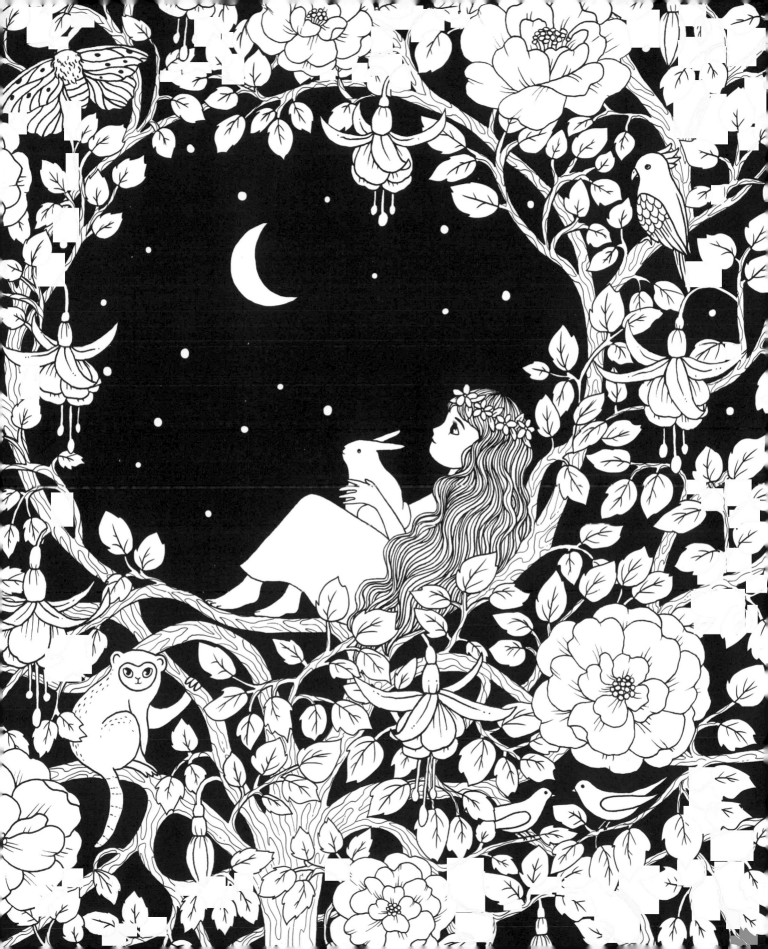

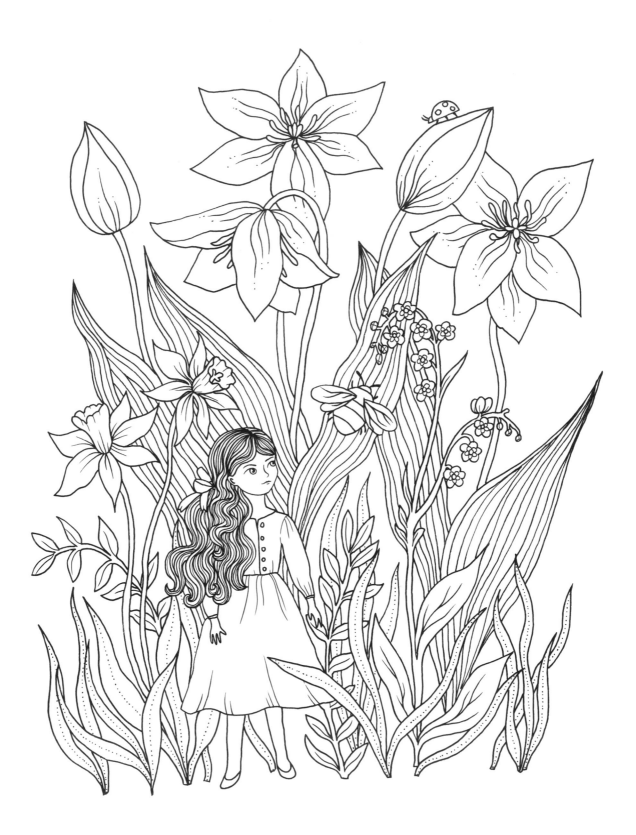

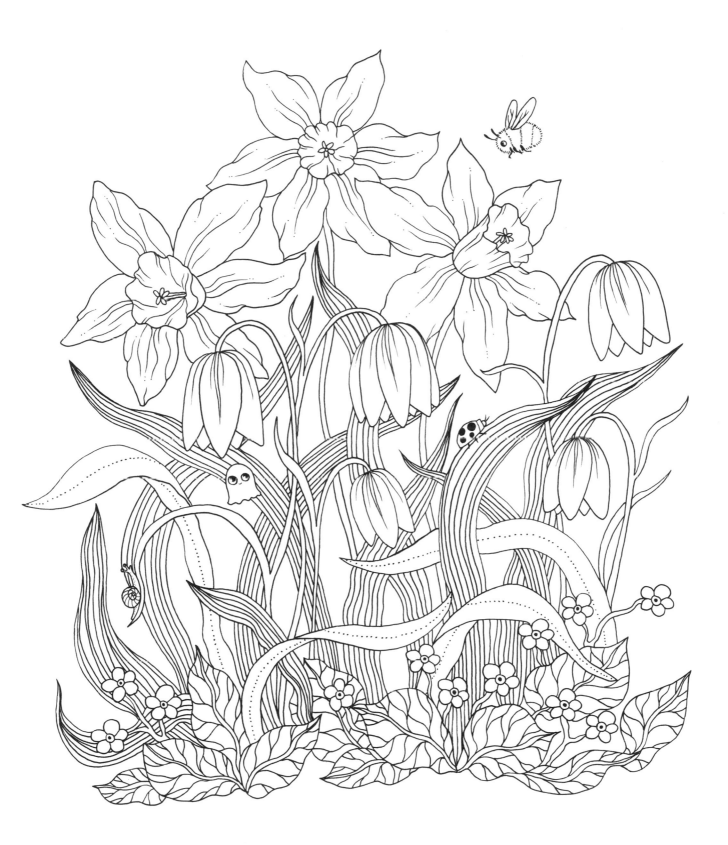

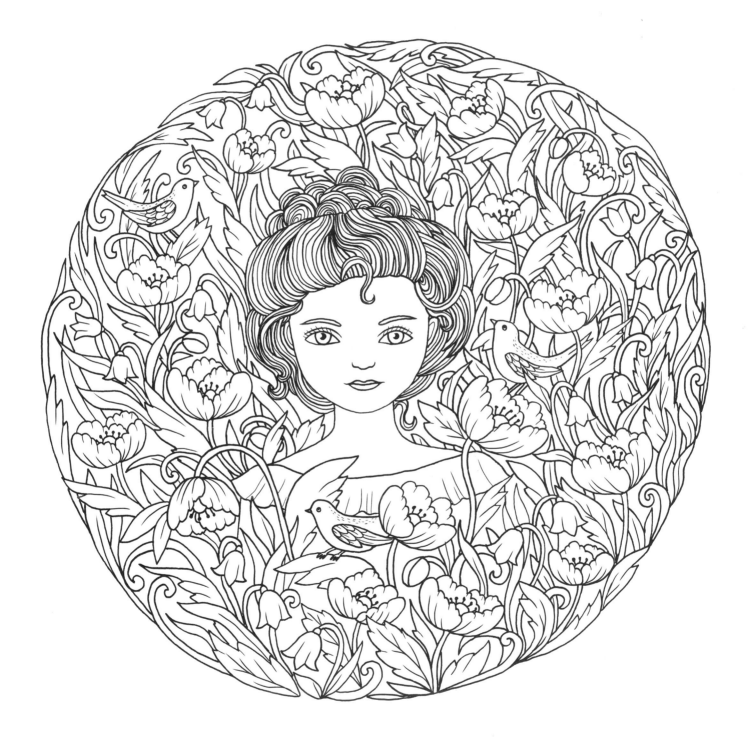

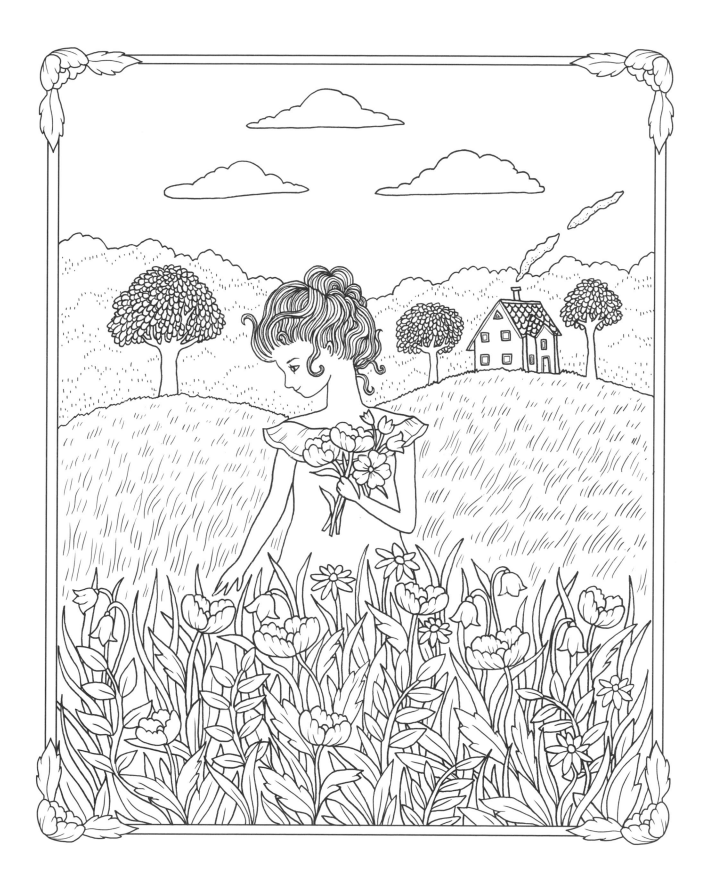

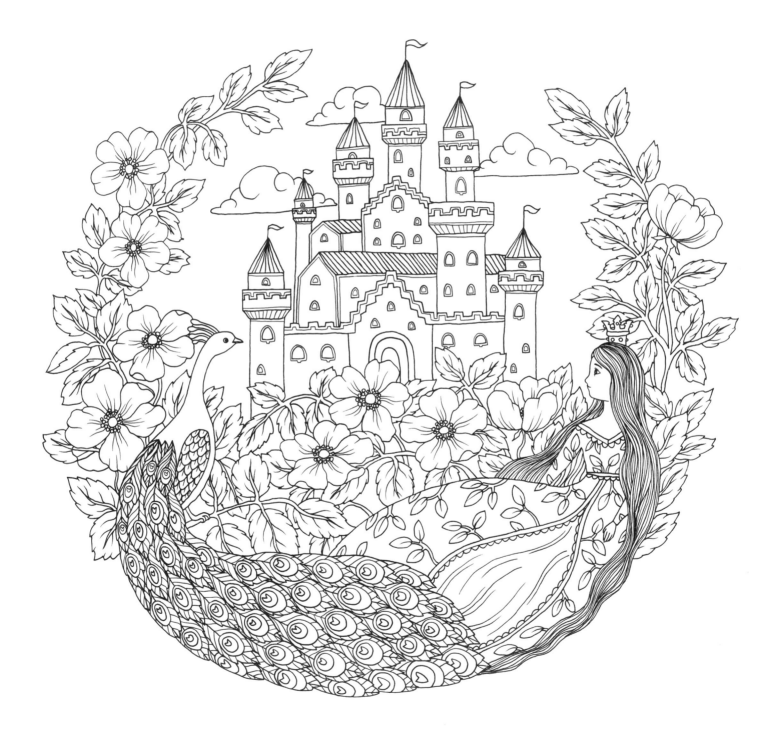

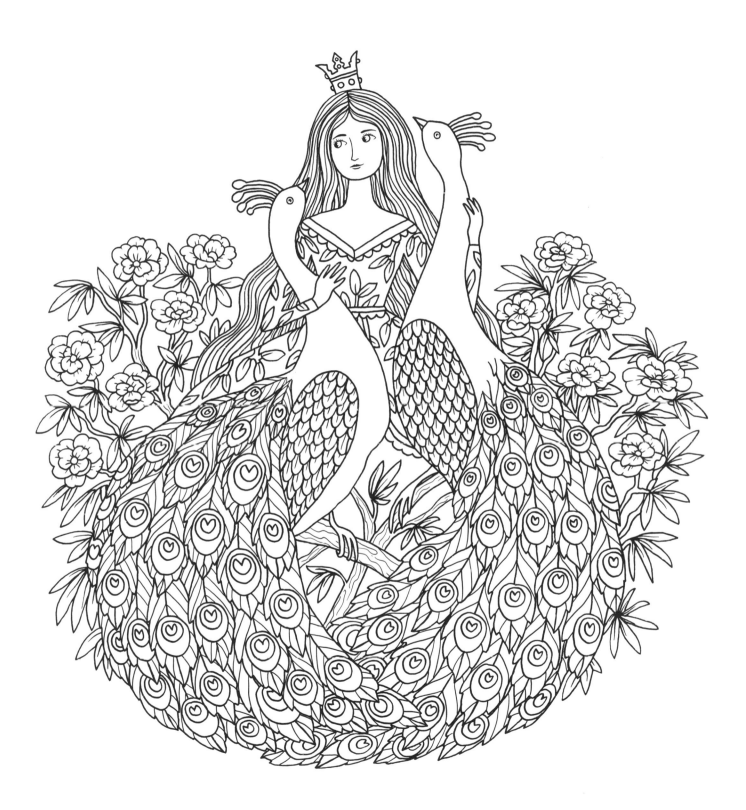

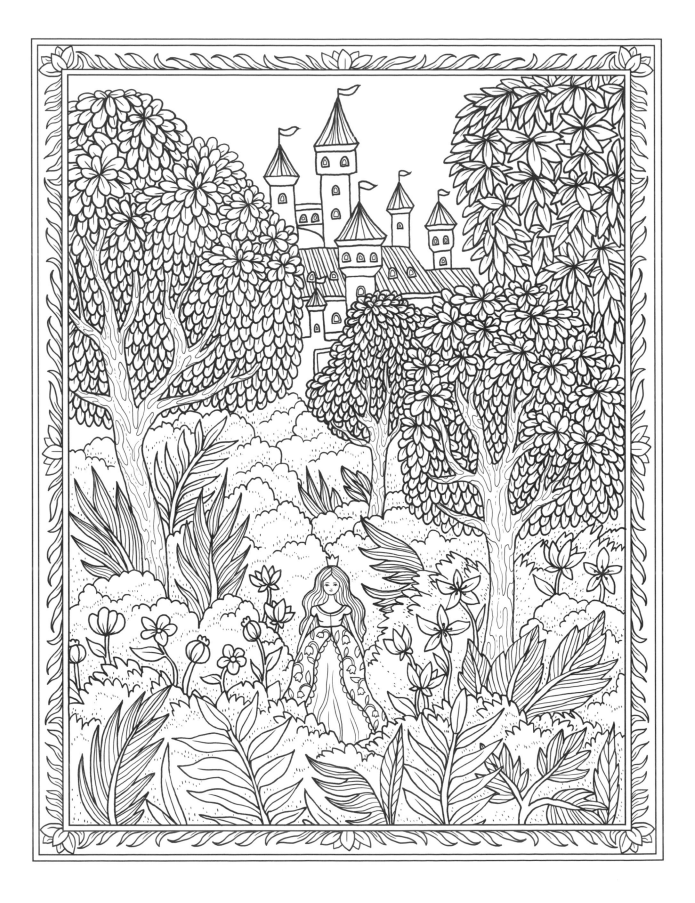

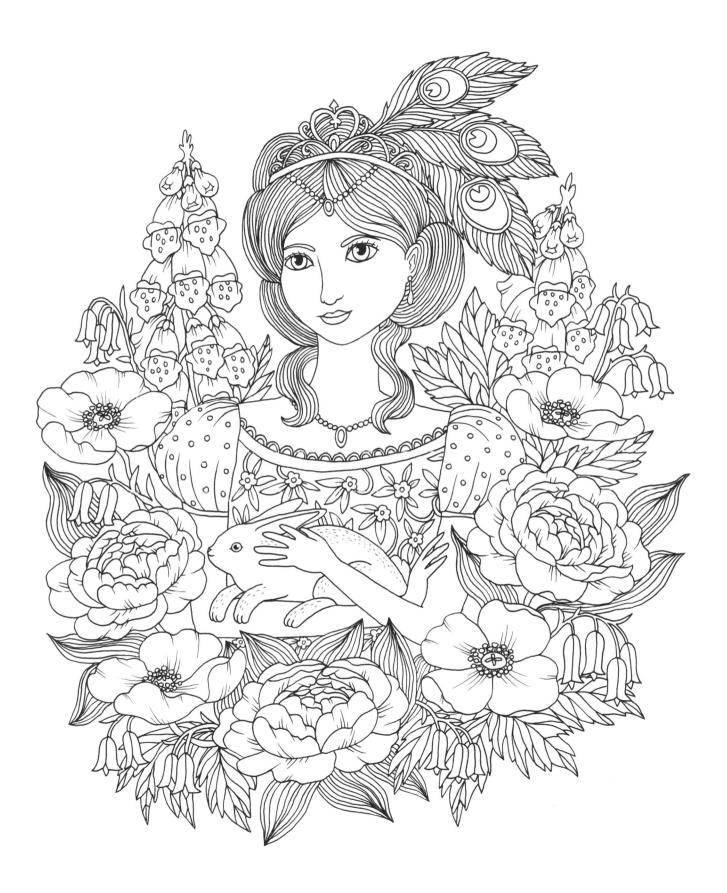

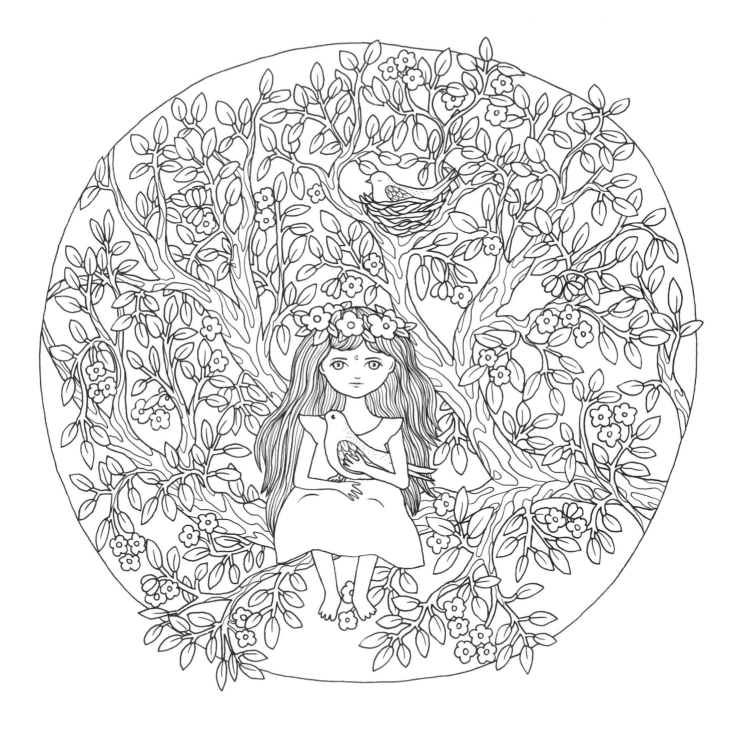

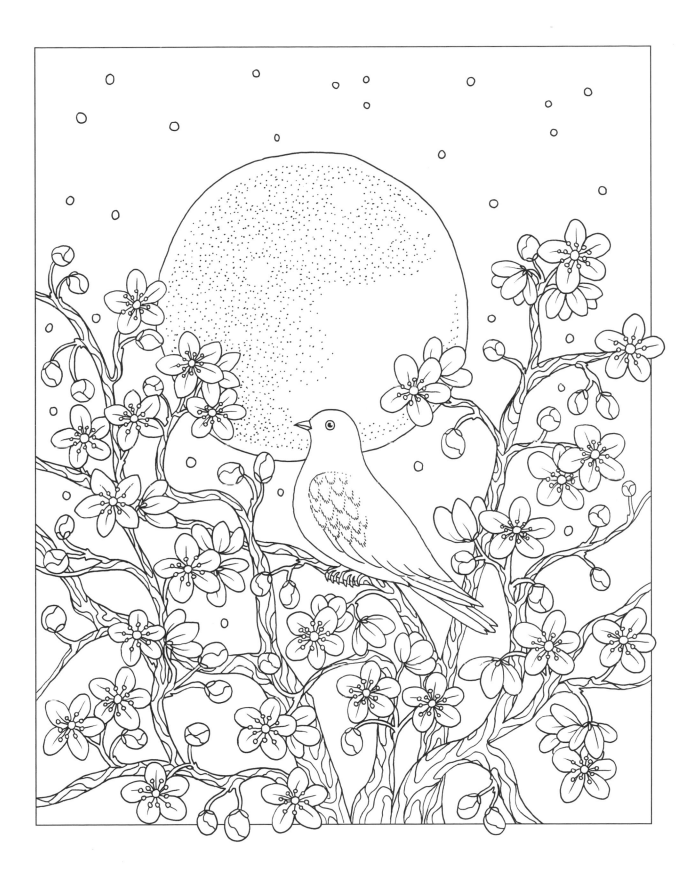

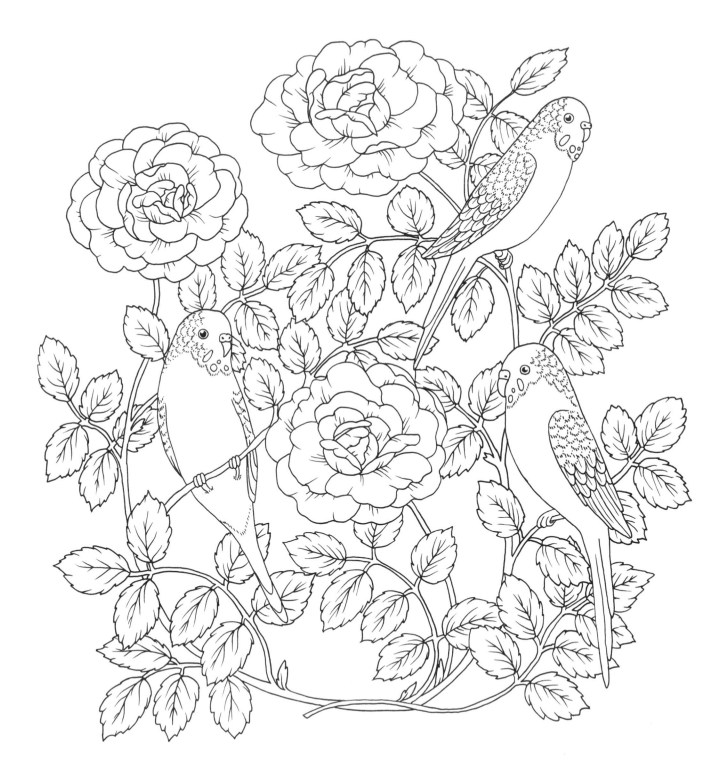

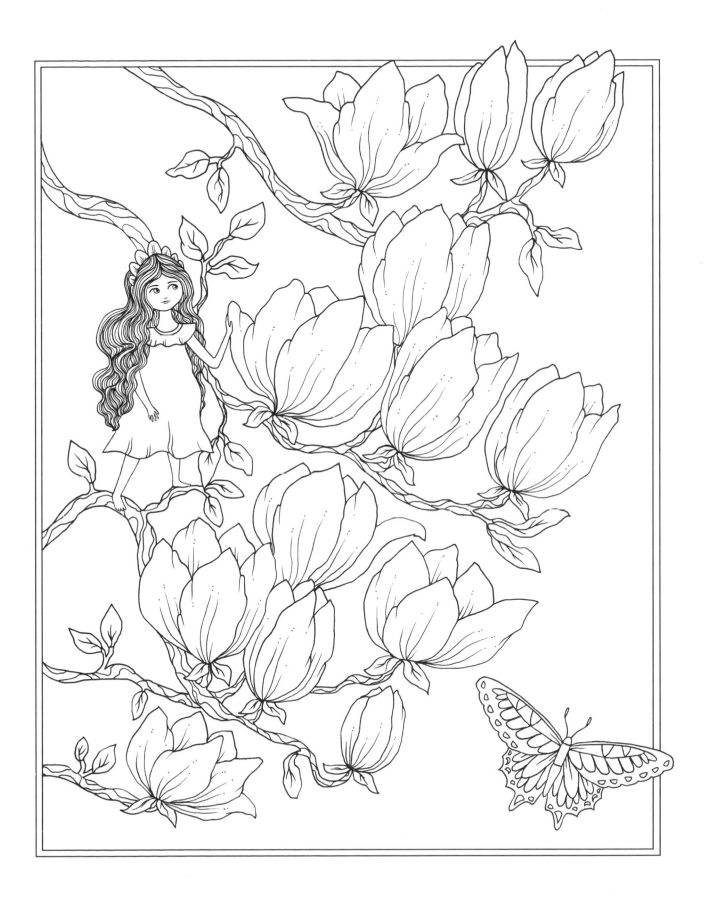

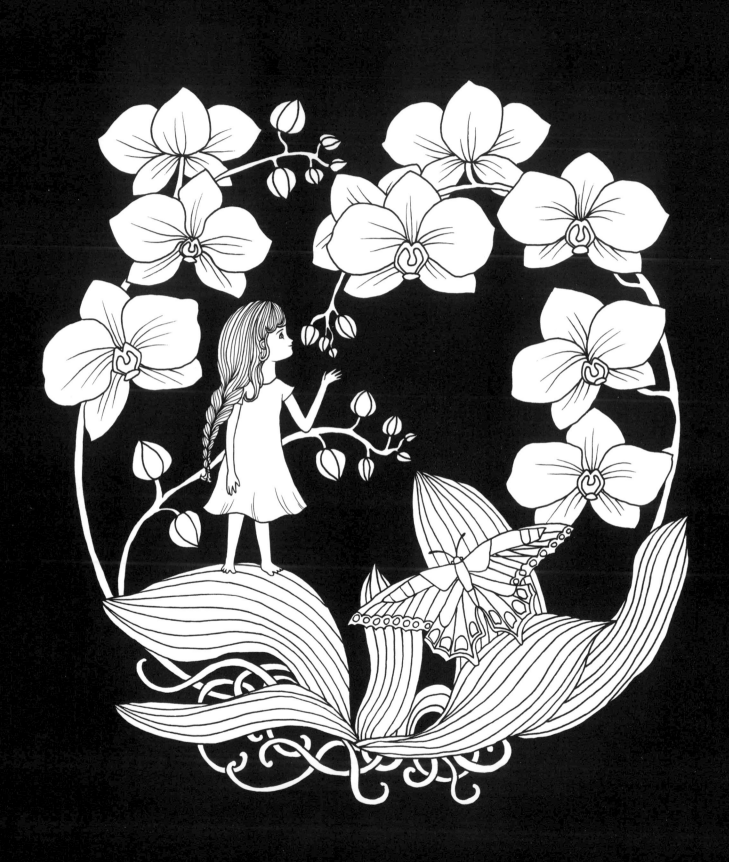

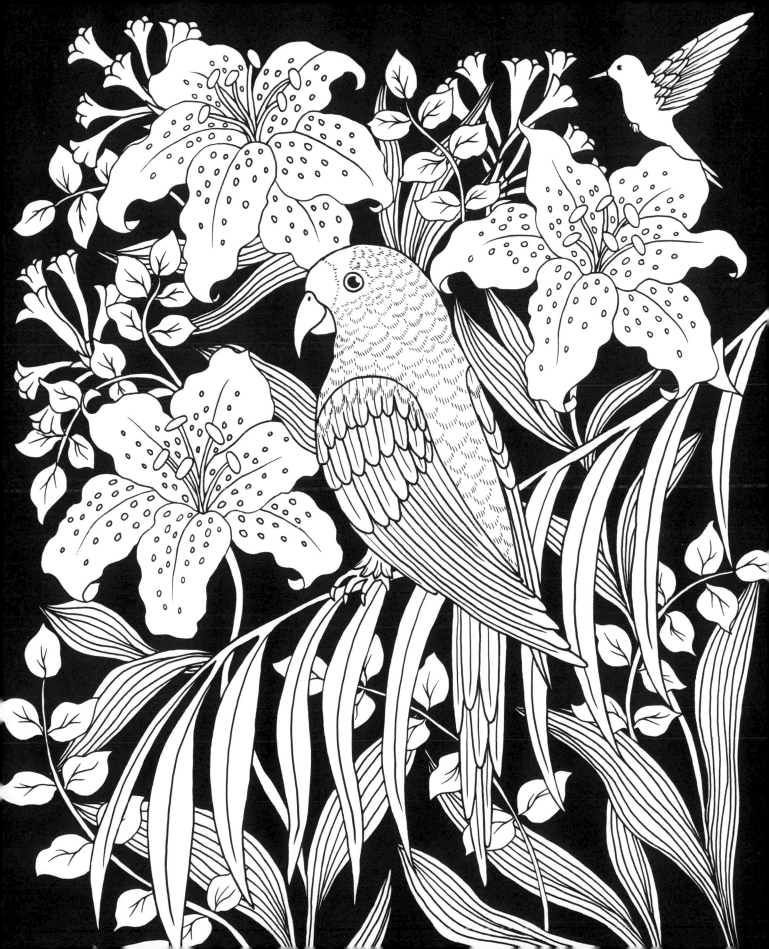

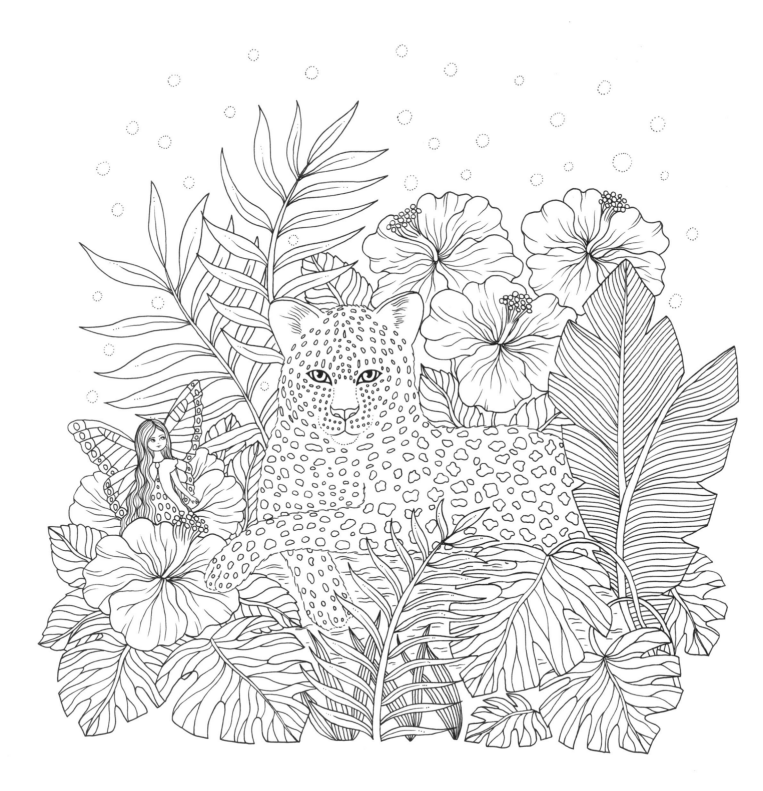

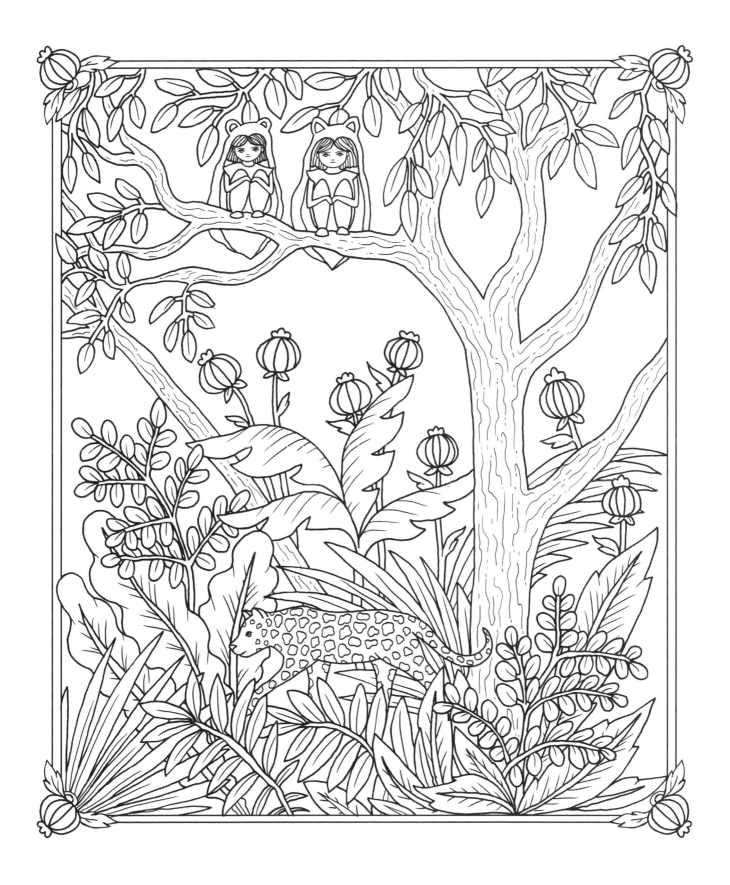

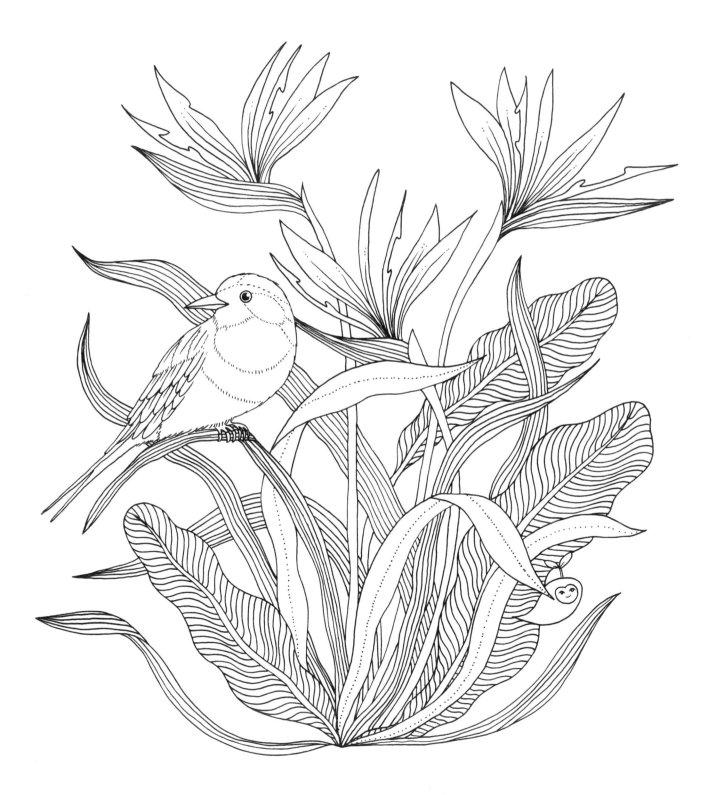

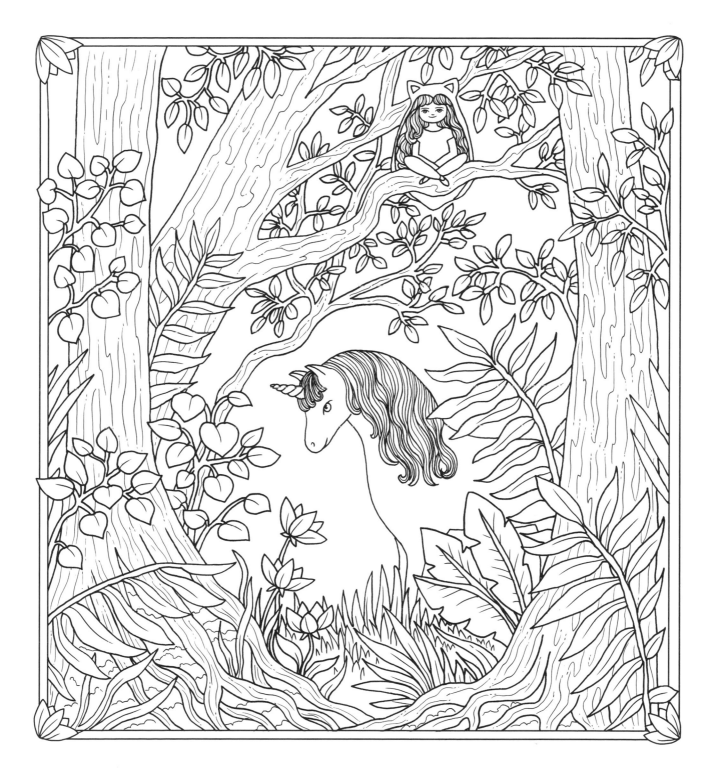

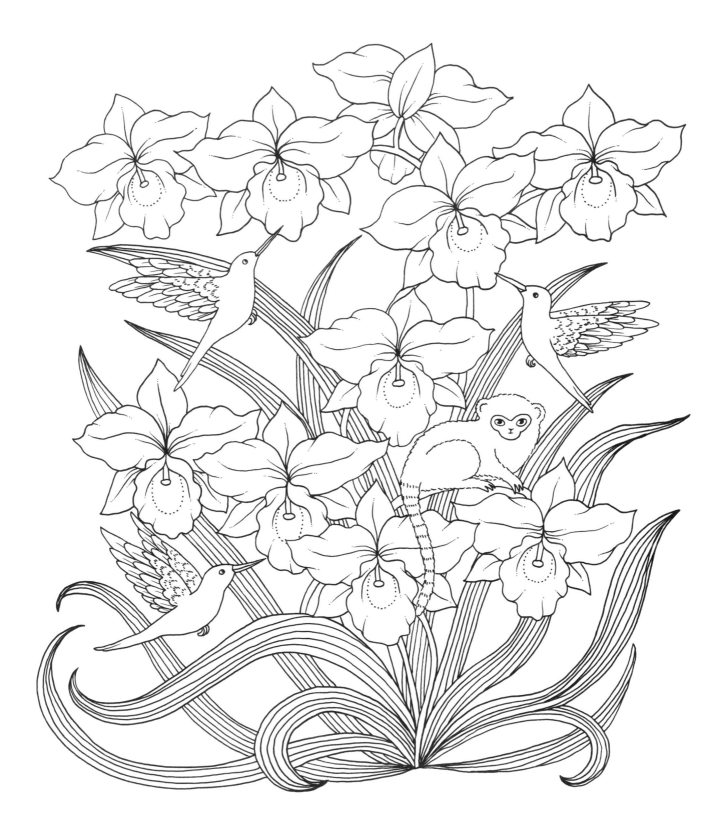

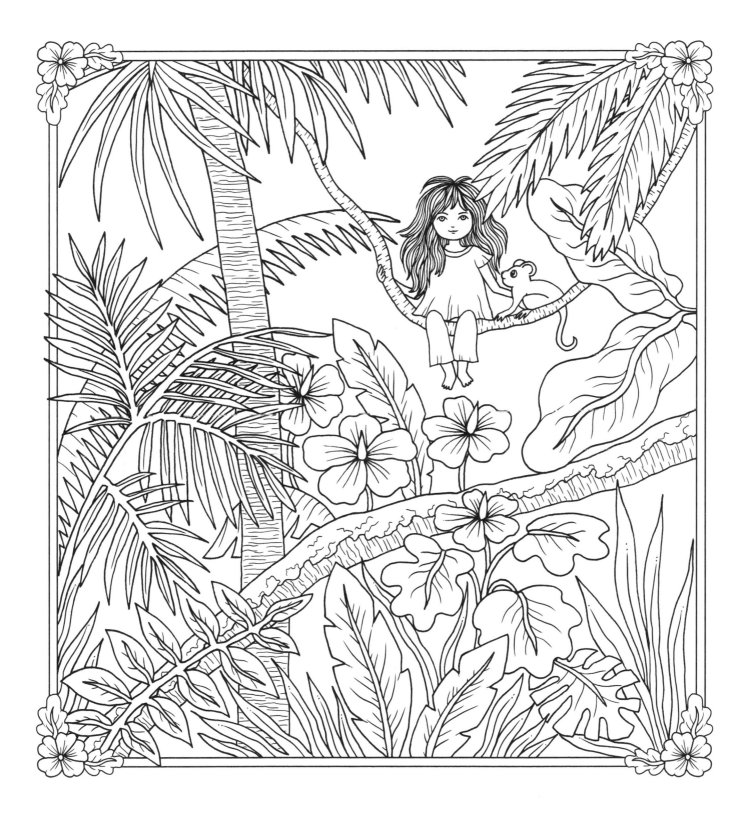

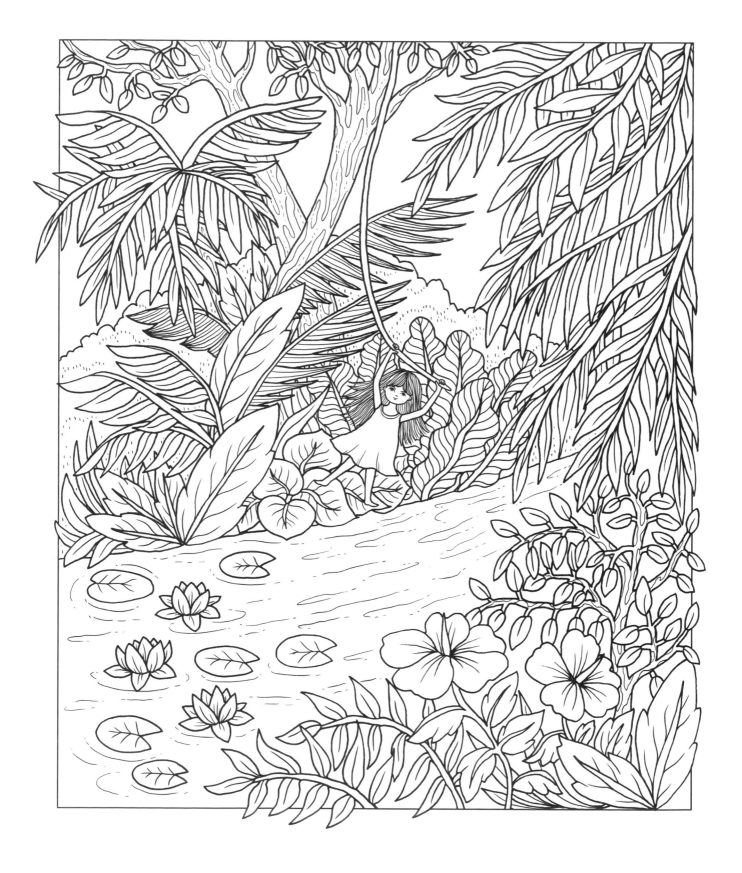

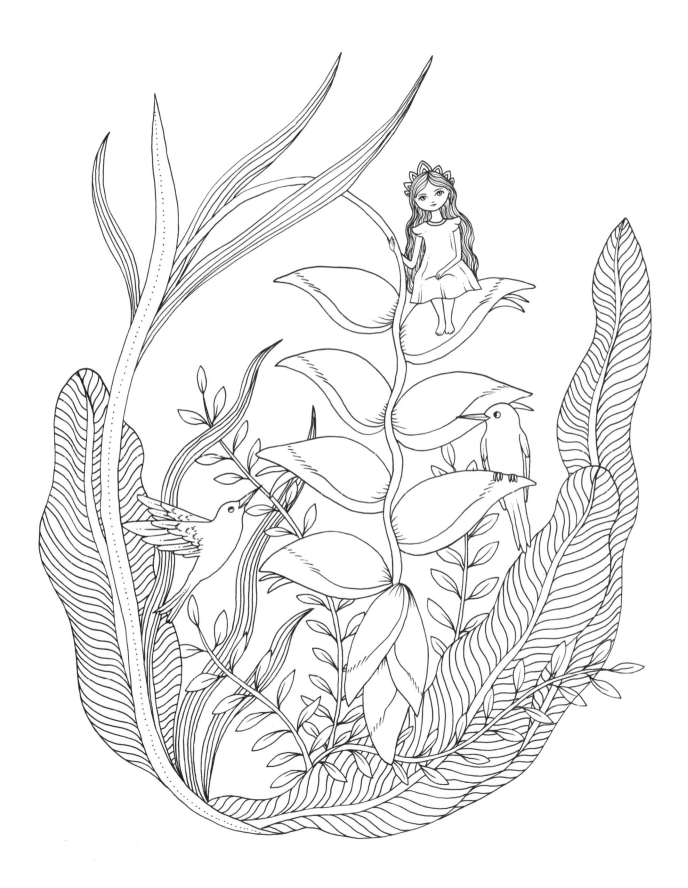

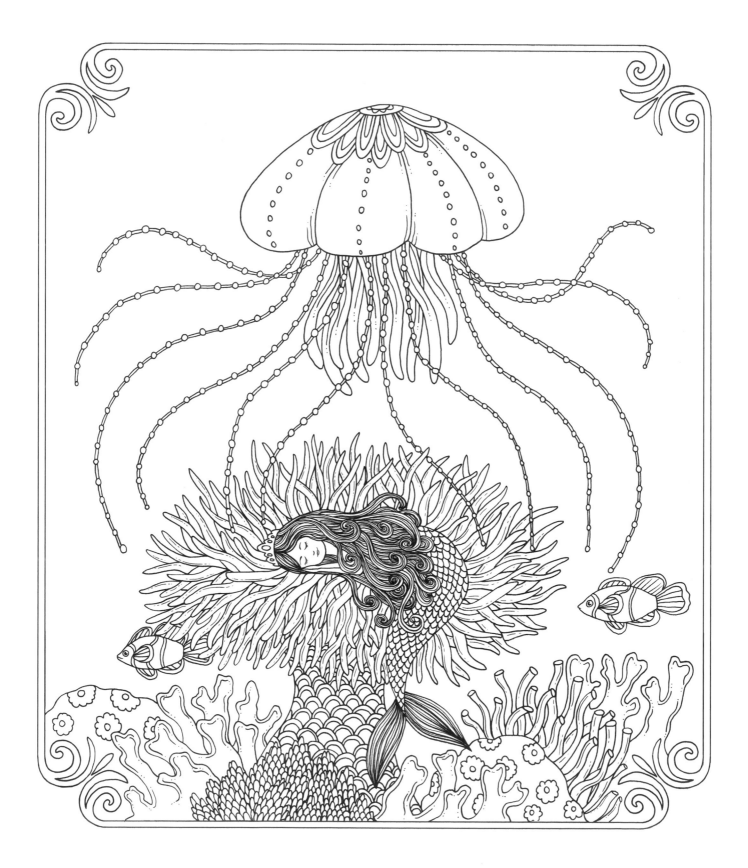

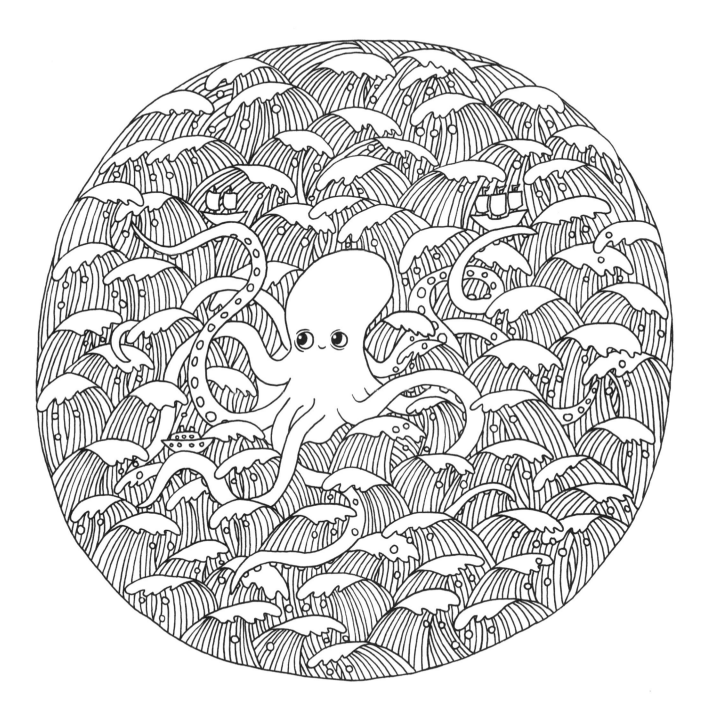

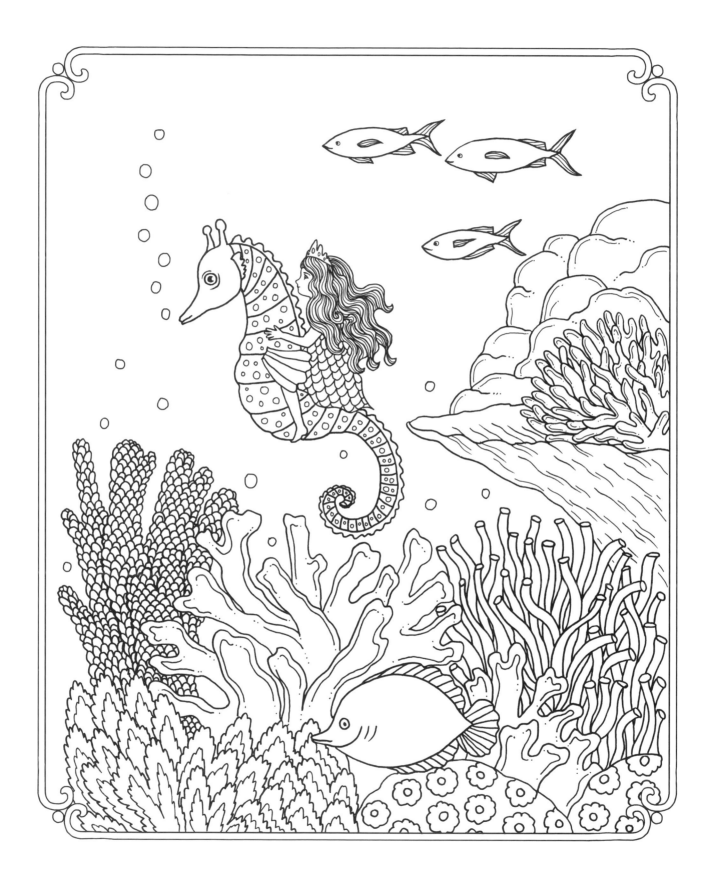

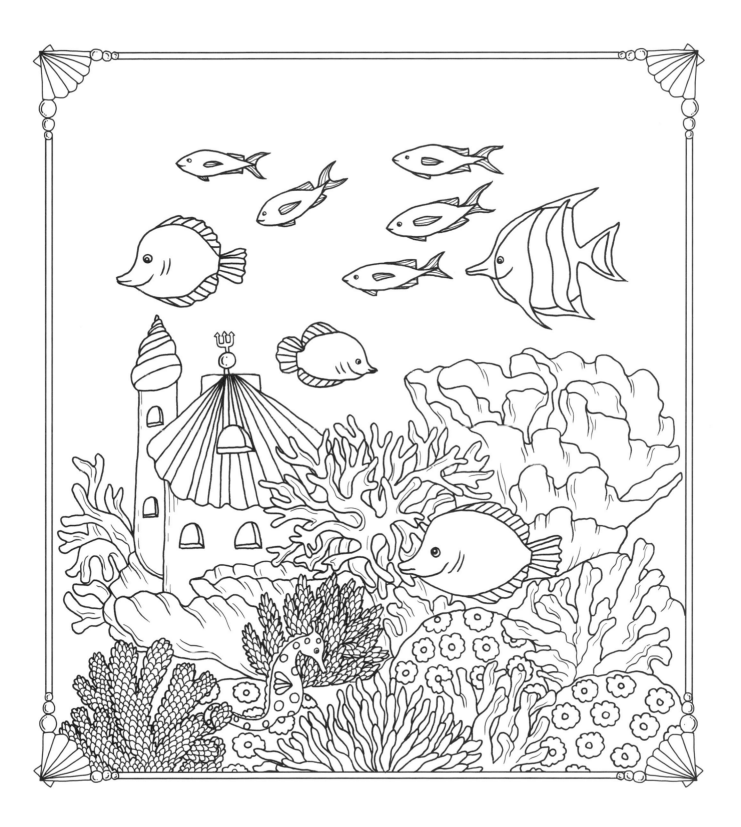

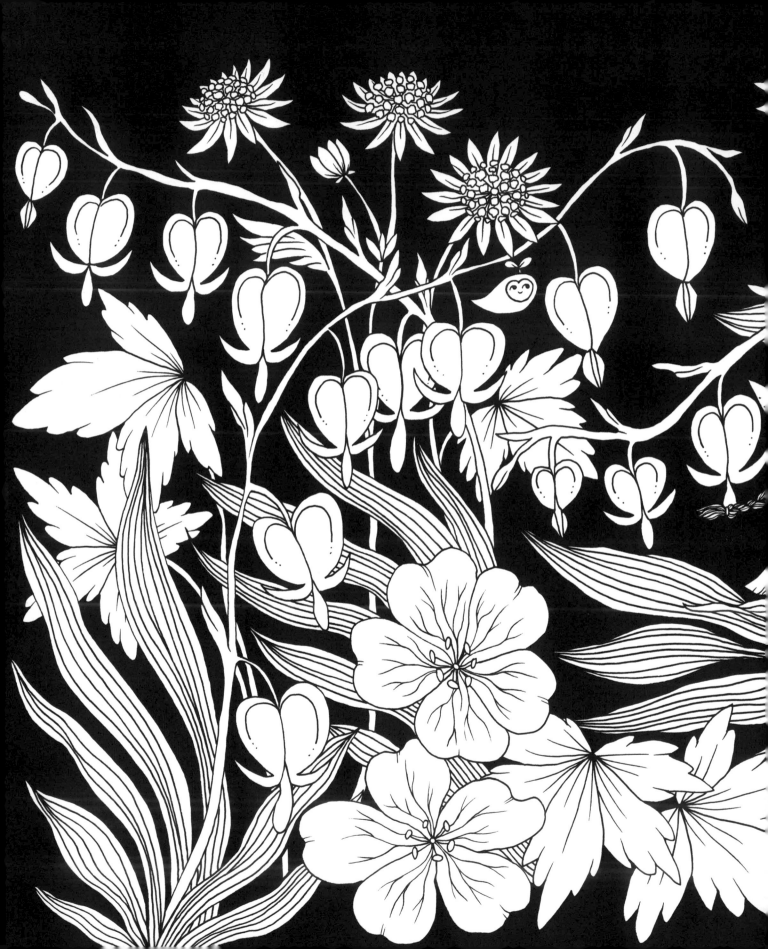

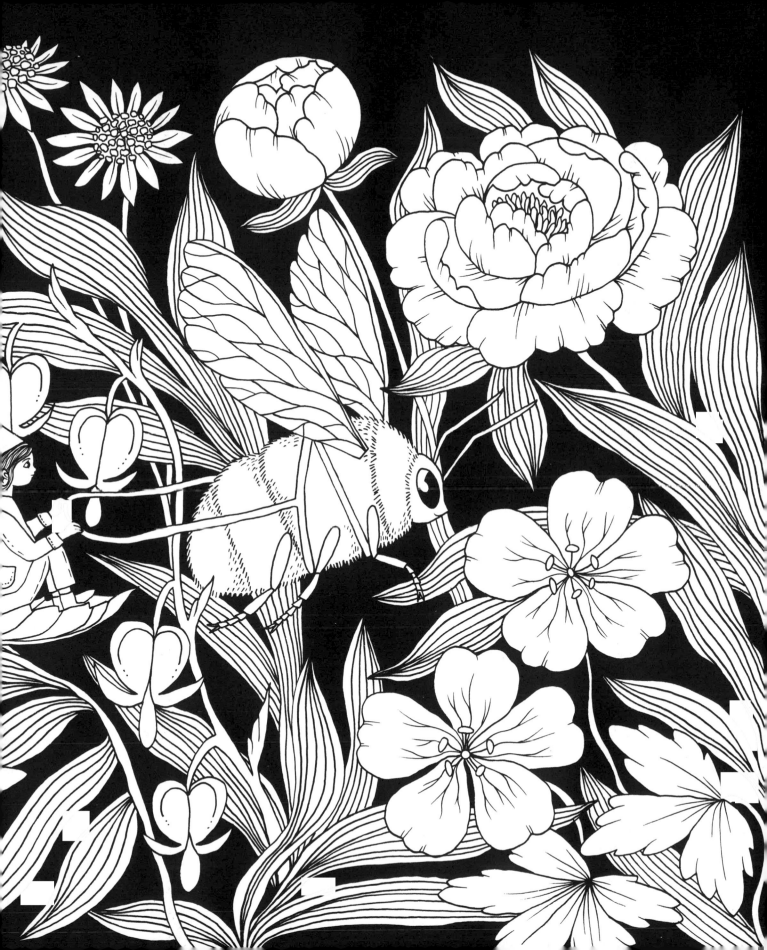

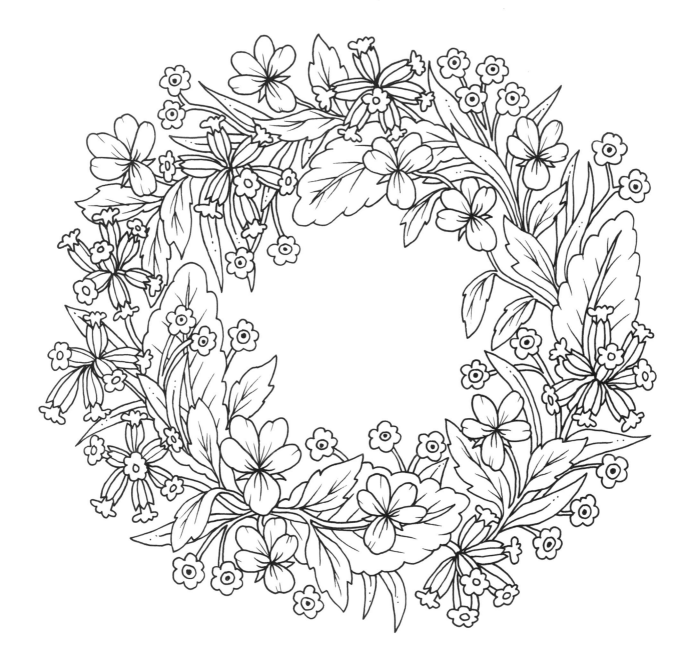

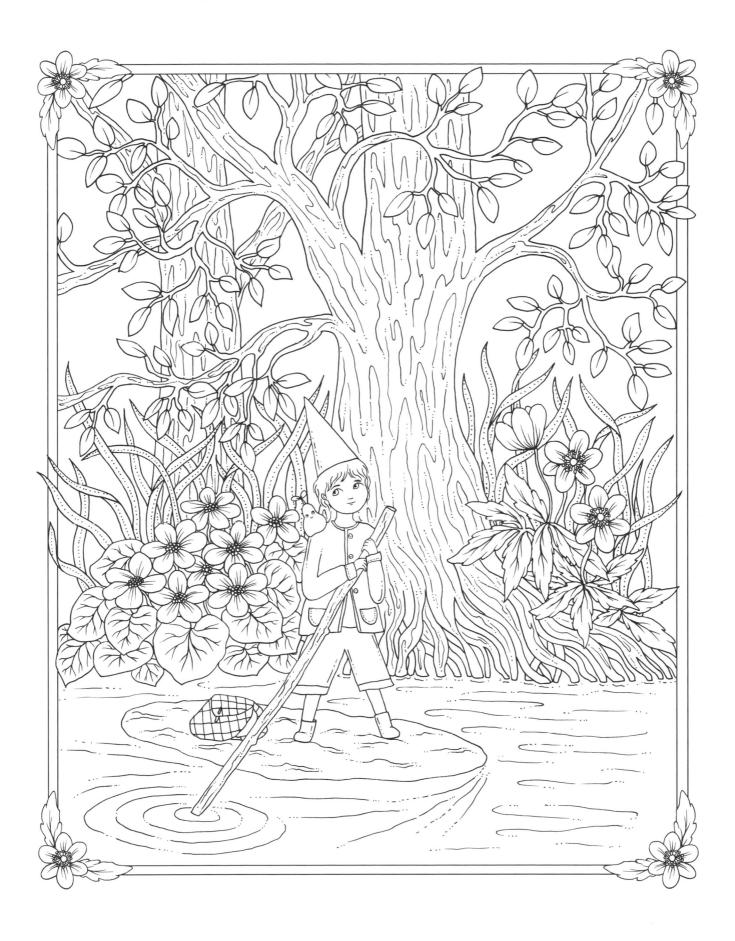

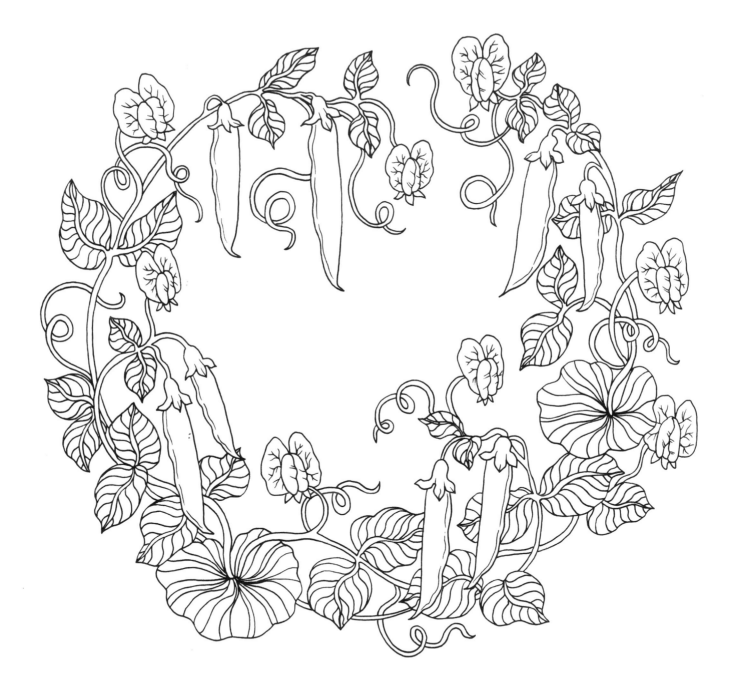

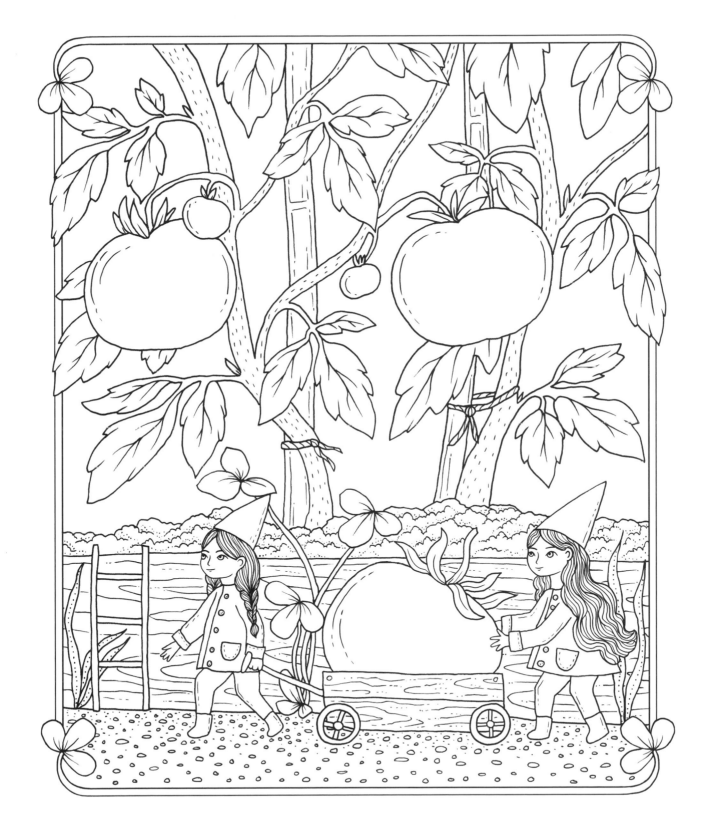

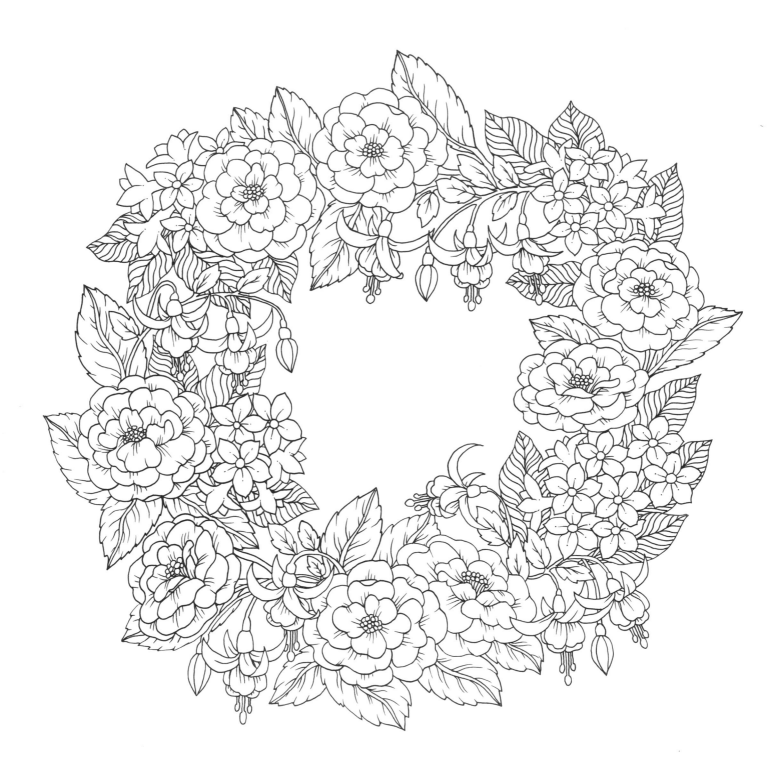

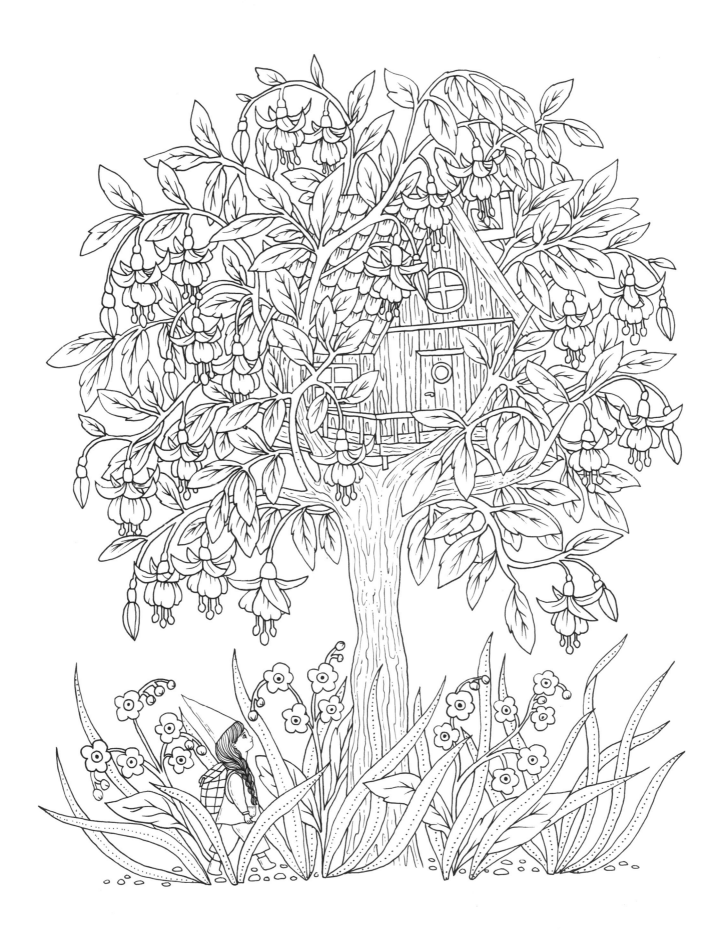

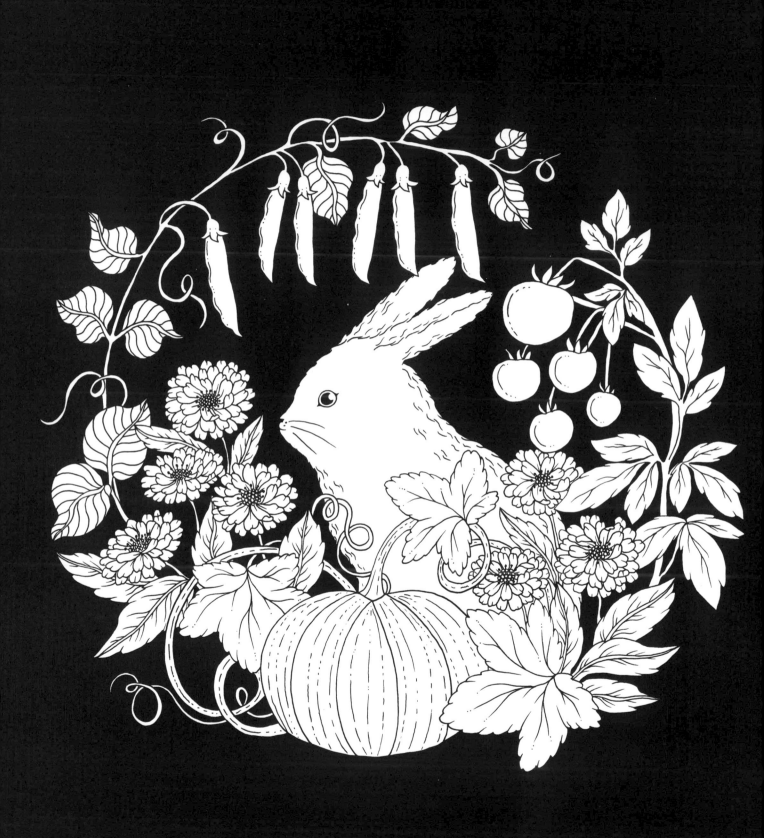

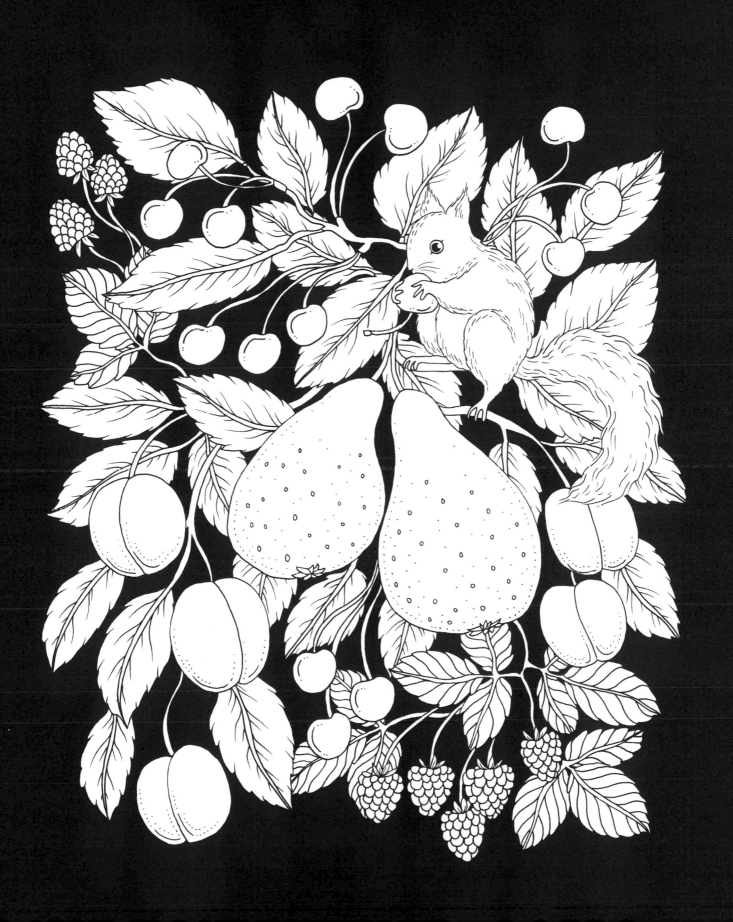

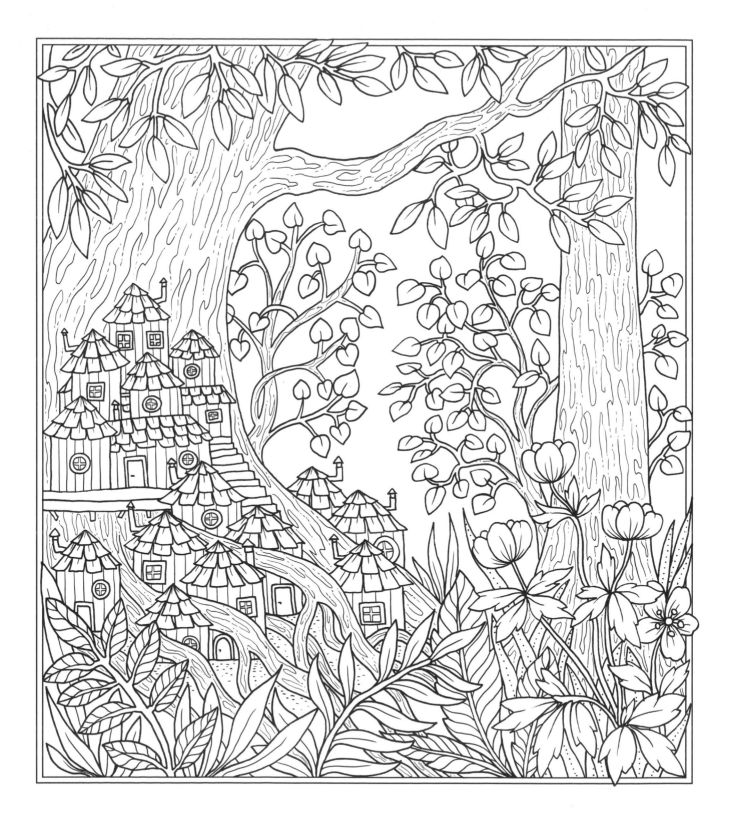

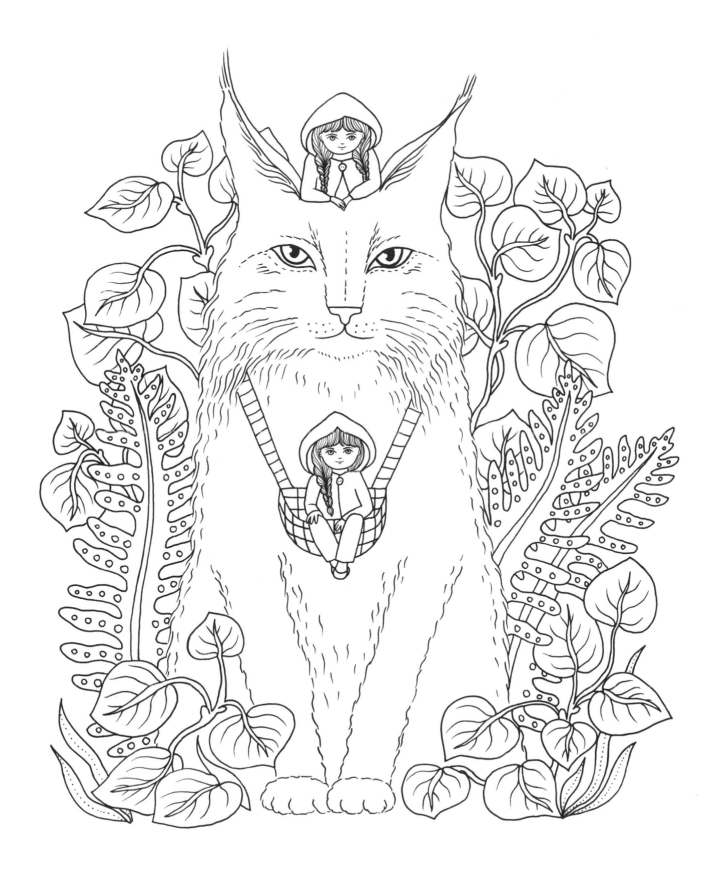

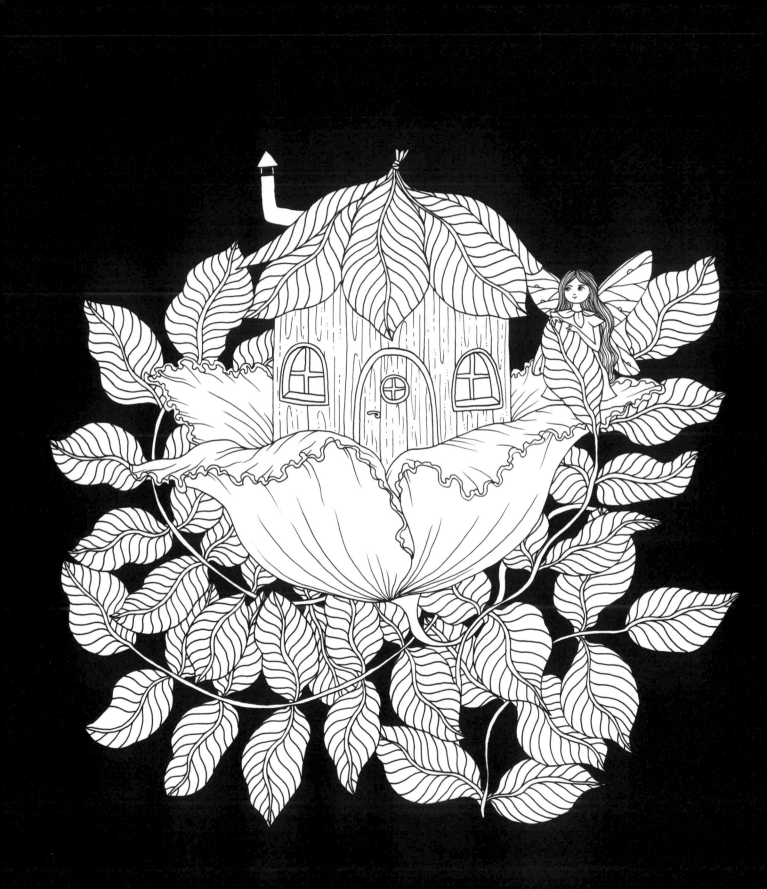

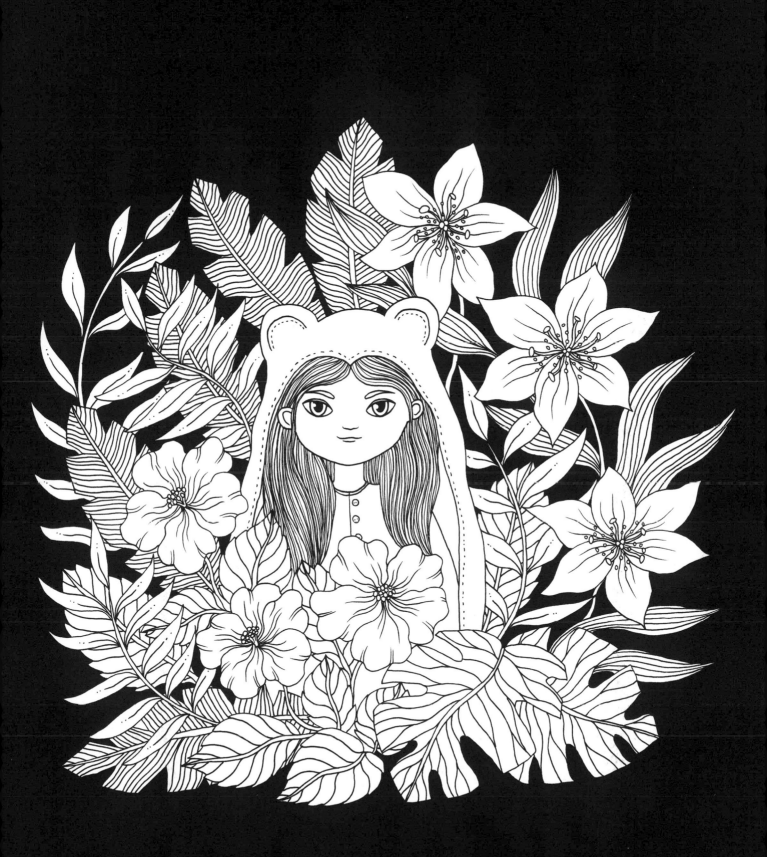

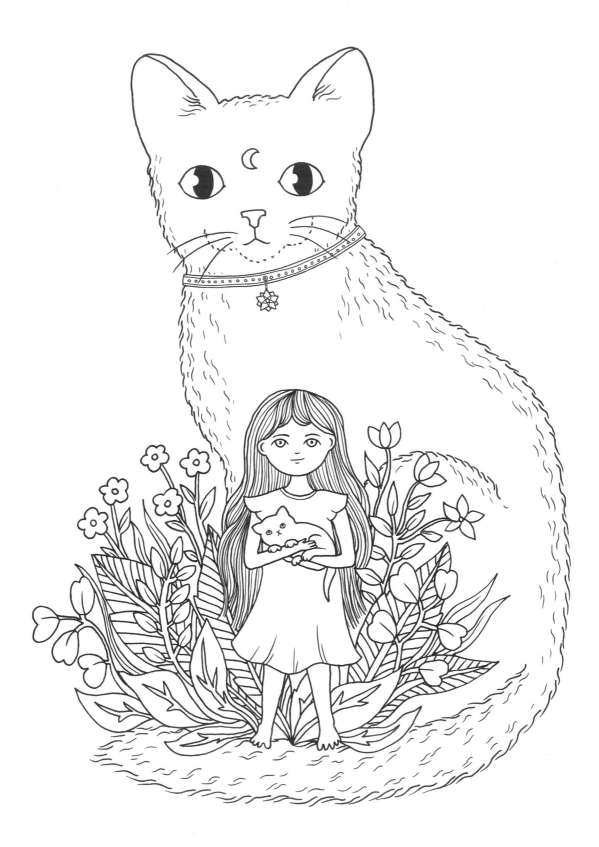

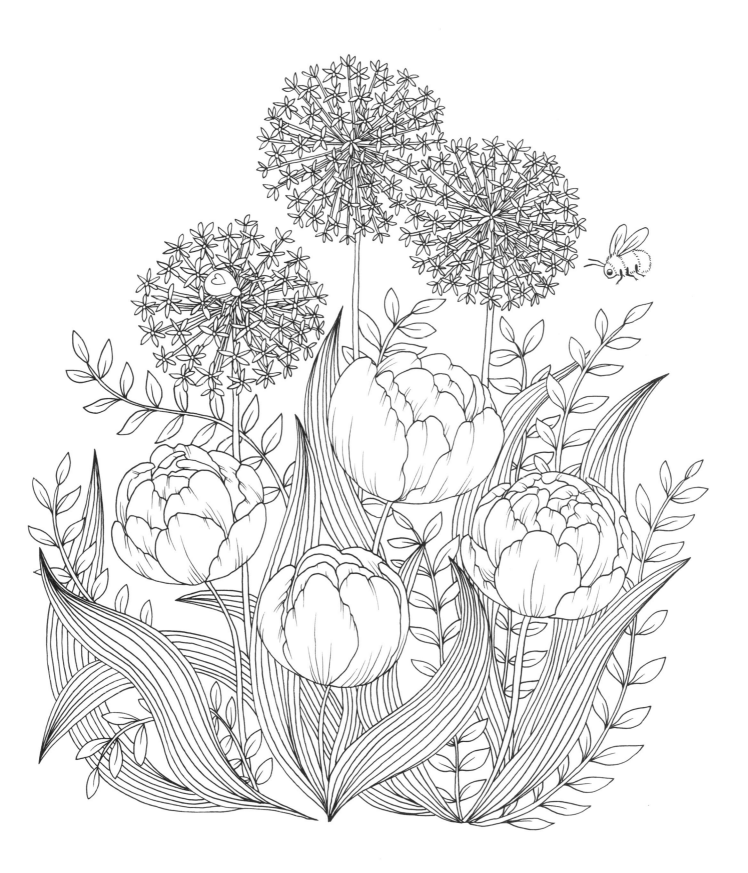

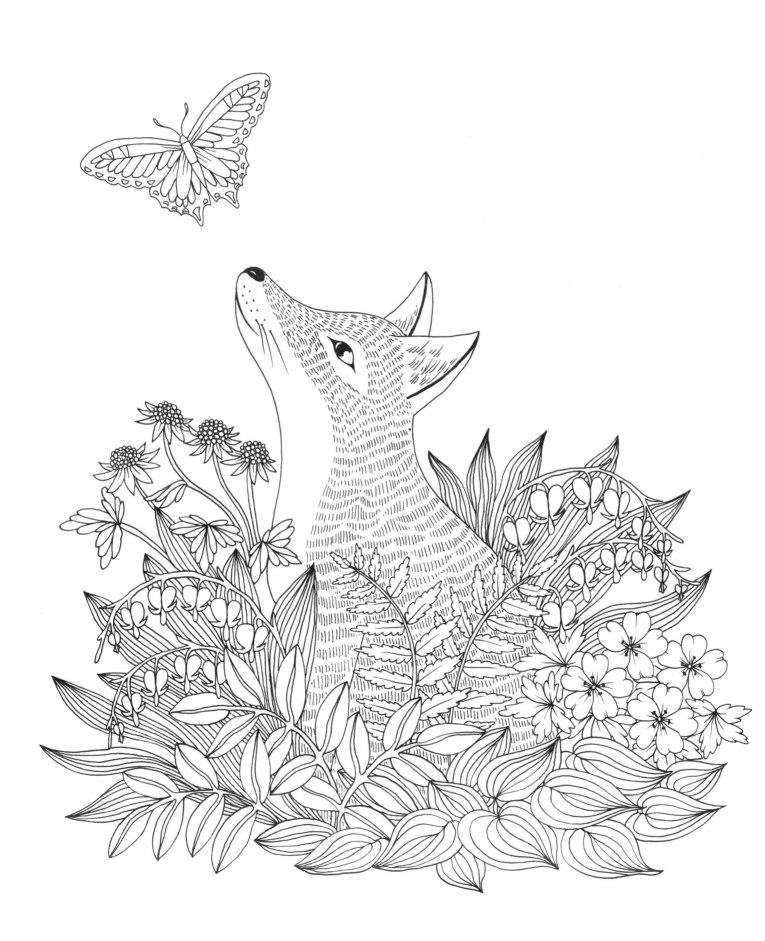

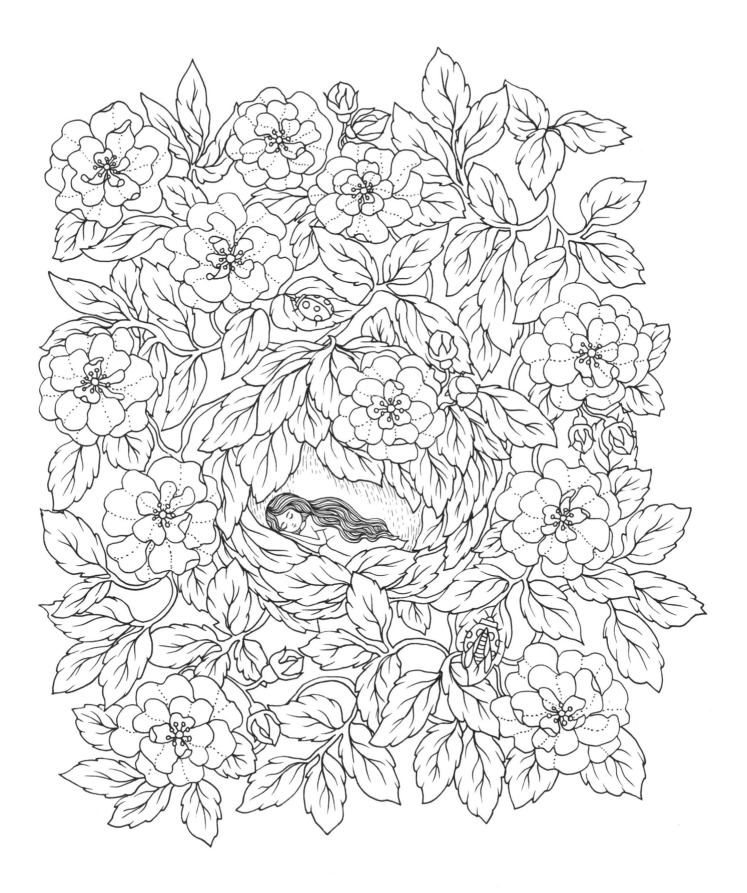

PLANT REGISTER

Plant names listed page by page;
numbering begins with the title page as 1.

ANIMAL REGISTER